IMAGES
of America

CHEROKEE STRIP LAND RUSH

At one time, vast stretches of tall- and short-grass prairie extended from what is now Canada into northern Texas. These seas of grass, broken by the occasional river course, salt plain, or collection of hills, have represented many things to the people who encountered them. For some, they were useless, foreboding barriers. For others, they were the very embodiments of opportunity. (Courtesy Jay M. Price.)

On the cover: Settlers wait for the rush. (Courtesy Cherokee Strip Land Rush Museum.)

IMAGES
of America

CHEROKEE STRIP
LAND RUSH

Jay M. Price, Editor

ARCADIA
PUBLISHING

Published by Arcadia Publishing
Charleston, South Carolina

Printed in the United States of America

Library of Congress Catalog Card Number: 2006927405

For all general information contact Arcadia Publishing at:
Telephone 843-853-2070
Fax 843-853-0044
E-mail sales@arcadiapublishing.com
For customer service and orders:
Toll-Free 1-888-313-2665

Visit us on the Internet at www.arcadiapublishing.com

Establishments such as the Elephant met the drinking needs of some rushers. In many areas, plain water was a luxury. Rev. A. V. Francis recalled in *The Home Missionary*, January 1894, that in Perry, "the government well was salt. In the middle of the afternoon some enterprising man appeared with several barrels of water which he had hauled fifteen miles, and he sold it at five cents per glass," (Courtesy Cherokee Strip Land Rush Museum.)

CONTENTS

ACKNOWLEDGMENTS

Books of this type are always team efforts. The project team is very appreciative for all the assistance that we have received from the staff of the Cherokee Strip Land Rush Museum; the Oklahoma Historical Society; the Wichita State University Libraries, Department of Special Collections; the Wichita-Sedgwick County Historical Museum; the Pioneer Woman Museum; the Library of Congress, *Harper's*; the *Wichita Eagle*; the Five Civilized Tribes Museum; the Osage Tribal Museum; the Cherokee Heritage Society; the Coleman Company, Inc; and the Museum of the Cherokee Strip, Oklahoma Historical Society. Many individuals have been valuable sources of information and sounding boards. These include Betty Jo Scott, James Coyne, Sharon Hartin Iorio, Janet Rhoads, Harley Anderson, Elma Stroad, Bret Carter, Marty Tipton, Phillip Moseley, and Lynn Smith. We also want to say thank you to the many friends, family, colleagues, and students who have all been supportive during this project. Finally, thanks also go to all the photographers, professional and amateur, who took the images that went into this book.

A note here on sources is in order. Unless otherwise noted, photographs are courtesy of the Cherokee Strip Land Rush Museum in Arkansas City, Kansas. Quotations have come from a variety of recollections. Many come from an unpublished collection of personal stories at the Cherokee Strip Land Rush Museum. Unless otherwise noted, all quotations come from this collection. Those from published works will have the full citation of the work in the bibliography at the end of this book. In particular, several quotations have come from a collection of accounts compiled by the Ponca City Chapter of the Daughters of the American Revolution in its book *The Last Run*. The project team thanks the chapter for its kind permission to use these quotations in the book.

The reader should realize that a given quotation does not refer to the specific image above. Rather, the quotations are examples of situations that the photographs represent.

Project Team:
James Crawley
Heather Ferguson
Constance Martin
Donita Neely
Jay M. Price
Melissa Thompson
Craig Torbenson
Tamara Weihe

INTRODUCTION

Up to our own day American history has been in a large degree the history of the colonization of the Great West. The existence of an area of free land, its continuous recession, and the advance of American settlement westward explain American development.

—Frederick Jackson Turner

On July 12, 1893, historian Frederick Jackson Turner uttered these words at the beginning of an address to the American Historical Association meeting in Chicago. Nearby, the nation celebrated the 400th anniversary of Christopher Columbus's expedition to the New World in its Columbian Exposition of gleaming white classical columns, electric lights, and the latest technology. America, it seemed, was leaving behind the days of frontier settlement to embark on a promising yet uncertain new age.

While Turner pondered the historical significance of the frontier's closing, one of the last dramas of this westward settlement was getting ready to take place nearly 600 miles to the south. Ever since the Kansas-Nebraska Act of 1854, the government carved out parcels from Indian Territory and opened them up to white settlement. Parcel by parcel, lands once promised to a wide range of Native American tribes shrank as the government officially purchased or reallocated pieces of what had once been considered the Great American Desert. After the Civil War, ever growing numbers of whites pushed to open up more land, sometimes simply marching out onto the prairie to try to settle by show of force.

White Americans had been ambivalent at best toward tribal sovereignty. As the 1800s unfolded, those attitudes shifted more and more toward assimilating Native Americans into Euro-American society, an attitude embodied in policies such as the Dawes Act. These policies became vehicles through which ever greater sections of Native American lands were opened up to settlement. The year 1889 was the beginning of the end for the remnants of Indian Territory when a large area called Oklahoma opened up. Communities such as Oklahoma City and Guthrie sprang up literally overnight.

In the summer of 1893, attention turned to a six-million-square-acre parcel known officially as the Cherokee Outlet. Common parlance, however, called it the Cherokee Strip. It had once been hunting lands for the Cherokee. After the Civil War, the government reallocated parts of it for several other Native American tribes from the Osage to the Ponca. Later on, a syndicate of cattlemen leased the remainder of the outlet for grazing purposes. Entrepreneurs in Wichita and Arkansas City saw white settlement in Indian Territory as a promising new source of investment and development. Native Americans were divided between those who wanted to maintain a

degree of autonomy and those who saw economic development as the best option in the face of unstoppable white expansion.

The contrast between 1889 and 1893 was striking. The 1889 rush unleashed 10 years of pent-up boomer enthusiasm and resulted in the creation of a whole new territory. The 1893 run took place in the midst of the worst depression to that time as well as a severe drought. Meanwhile a vocal movement called Populism extolled the virtues of the small farmer, reinforcing the view that land should go to settlers and town builders instead of large ranch owners.

The Cherokee Outlet officially opened at high noon, September 16, 1893. Thousands of individuals flocked to the region. Some sought new lives and fresh starts. Others anticipated a new boom in real estate investment. Merchants contemplated business opportunities in railroad stops such as Alva and Enid, stops destined to be new towns.

Individuals arrived to register for a chance to run and claim a parcel of land. What they found were tent cities, stifling heat, and a land baked to a dusty inferno. Supplies could be had, but for a price. Even horses of marginal quality could cost over a year's wages. Prospective settlers passed the time anticipating the best spot from which to run and the best parcel of land to select once there. Meanwhile soldiers patrolled the outlet to evict "sooners" who sneaked onto the land ahead of the official opening.

When the gun went off, the chaos and energy that ensued was unforgettable. This mixture of enthusiasm and desperation captivated the press. Newspapers recounted incidents of people on wagons, horses, and foot struggling over the land. Trains raced down the tracks that crossed the outlet, and people scrambled off the cars to claim parcels nearby. Some were trampled in the rush. Others got caught in obstacles.

Confusion reigned. Two people, hidden by a small hummock, might inadvertently claim the same parcel. Resolutions to those conflicts ranged from gentlemanly negotiation to financial wheeling and dealing to litigation to cold-blooded murder. Claiming land in the town sites was not necessarily easier. Several claimed land only to find their parcels already designated as roads or public institutions. Many who made the run that day went home empty-handed.

Those who made claims found their struggles just beginning. Some perished in the grass fires that raced over the tinder-dry land. The opening took place at the end of summer, and settlers had to endure a fall and winter with no crops and few resources to start a new life. Many spent that first year in dugouts—at a time when the nation's cities featured streetcars, electricity, running water, elevators, and department stores.

Those who endured, however, went on to build Oklahoma Territory. Soon after the rush, oil transformed the region. Cities and towns developed an array of businesses and industries. Entrepreneurs and community builders from places like Kansas developed institutions in Oklahoma—and, as the 20th century unfolded, vice versa. By the time of Oklahoma statehood in 1907, the region was bustling with farms, towns, rail lines, and oil wells. Diverse populations from Native Americans to Mennonites reshaped the former Cherokee Outlet. Even ranches such as the 101 maintained an important presence, combining cattle and oil with popular culture.

Then came the Great Depression. Those who experienced 1893 as youths entered what should have been their golden years with the specters of dust clouds rolling over the land. The hard work of a generation disappeared under a sea of sand dunes. Many children and grandchildren of the rushers had to make new lives for themselves in the region's cities or farther away in places like California.

Yet many others held on. In recent decades, those who stayed and those who arrived since the rush have continued to shape the region. The Cherokee Strip Land Rush has lived on in countless movies and monuments. What started as settlers' picnics formed the basis of a number of museums dedicated to telling the story of this dynamic, turbulent, colorful, tragic, and iconic segment of North American history.

One

CHANGE ON THE PLAINS

The lands that made up Indian Territory were not nearly as uninhabited as the common perception suggested. Different populations and perspectives struggled over the best way to occupy the land. For some Native Americans, these were places of seasonal settlement and hunting parties. For groups such as the Cherokee, these lands were new, unfamiliar homes, places of exile where life had to begin again. During the decades that followed, several generations of Native American families, businesses, and entrepreneurs had developed communities, institutions, and trading links in the region, including towns, ranches, farms, and railroad links. For ranchers and investors, both white and Native American, the land represented unlimited potential for development and profit. For the farmer, it was a place to make a life full of hardship and opportunity. In tribal lands, westernized native or mixed-ancestry leaders tried to develop their multicultural societies and encourage investment while maintaining local autonomy in the face of encroaching Anglo-American investors and settlers. In addition, there were as many different opinions within the tribes and other groups as between them. Sometimes white ranchers preferred to work with the tribes rather than the U.S. government. Those wanting to move to the area or invest in its opportunities pressured officials to simply open up the lands to settlement. As the 1890s unfolded, a national depression, political unrest, mounting distrust of big cattle barons, and an increasingly nostalgic view of the American farmer made opening up the region to agriculture and settlement nearly inevitable.

Rev. A. V. Francis, in *The Home Missionary*, January 1894, recalled, "Flowing eastward through the center of the strip is a stream called the 'Salt Fork' of the Arkansas River (shown here near Arkansas City). As the name indicates, its waters are strongly impregnated with salt . . . The government well at Perry, north of Orlando, is pure brine, and although 100 feet deep, the water is warm."

For centuries, peoples such as the Osage and the Wichitas lived in the region, often spending part of the year in the river valleys and part on the plains themselves. By the 1800s, the Osage, whose influence once extended far into the plains, had to negotiate a changing situation in the face of white expansion and a new array of Native American peoples. (Courtesy Osage Tribal Museum.)

In the 1830s, United States policy established Indian Territory, a vast collection of tribal lands that extended from Canada to Texas. This collection of tribal lands ranged from traditional hunting areas for Plains peoples to newly established homelands for tribes relegated to the interior of the continent from the Great Lakes and the Appalachians. Although officially off-limits to white settlement, Anglo-Americans started trickling in from the outset. Some leased or purchased land from the tribes. Still others simply squatted on the land without regard to who actually owned it. (Courtesy Wichita State University Libraries, Department of Special Collections.)

The southeastern part of Indian Territory was primarily the home of the "Five Civilized Tribes," consisting of the Cherokee, Choctaw, Creek, Chickasaw, and Seminole. Shown above is the union building in Muscogee where representatives of these tribes met with government officials. These tribes had generations of contact with whites and had incorporated elements of Anglo-American culture into their own, including schools, churches, an influential Masonic movement, and newspapers such as the *Cherokee Advocate*. (Above, courtesy Five Civilized Tribes Museum; below, courtesy Osage Tribal Museum.)

Courthouse
ahlequah, Okla.

Clark

Having endured the trek to new lands in Indian Territory, the Cherokee started anew and attempted to make a new nation out of these now combined eastern and western branches. They established new towns such as the capital of Tahlequah. Shown here is the capitol building that housed several offices of the Cherokee government, including the national council. Completed in 1869, it replaced one that burned during the Civil War (the photograph dates from the building's more recent use as a courthouse). From here, Cherokee entrepreneurs and politicians encouraged the development of towns and other ventures from railroad lines to cattle operations. (Courtesy authors' collection.)

Officially the Cherokee Strip is a long, thin tract of land about two miles wide that became part of the southern edge of Kansas. The larger section of lands just below that was technically the Cherokee Outlet, a vast area whose features ranged from high plains in the west to salt plains in the center to bottom land along the Arkansas River and its tributaries on the eastern side. However, by the late 1800s, popular discourse referred to the Cherokee Outlet as the Cherokee Strip as well. It is this later use that is generally referenced when referring to the Cherokee Strip Land Rush. (Courtesy Craig Torbenson.)

Divided over which side to support in the Civil War, some factions of the Cherokees sided with the North while other Cherokee sided with the South. Southern support on the part of some Cherokee leaders resulted, at the end of the war, in an 1866 treaty that included the ceding of the Cherokee Strip to Kansas and, it was assumed, eventual opening of the Cherokee Outlet. Parts of the outlet, meanwhile, were eventually set aside as lands for several resettled plains peoples. (Courtesy Jay M. Price.)

In 1872, the Osage received a large tract of land in the eastern part of the outlet between the Cherokee Nation and the Arkansas River. Once the dominant people from Missouri into Kansas, the Osage now had a small section of what had been to them hinterland, with the central town being Pawhuska. (Courtesy Osage Tribal Museum.)

The institution called the Ponca Agency actually oversaw the affairs of four groups: the Poncas, the Pawnees, the Tonkawas, and the Otoe Missourias. All four had lands located in the Cherokee Outlet west of the Osage territory. For example, the Poncas were a Souian-speaking people originally from what is now Nebraska. Once established, their government in this new section of Indian Territory argued strongly against opening the area to Anglo settlement. (Courtesy Wichita State University Libraries, Department of Special Collections.)

4000 BOOMER WAGONS CROSSING R.R.BRIDGE

Indian Territory had long been a diverse place with residents of Native American, European, Anglo-American, African American, and Latino backgrounds. In addition to the various tribes, people of mixed ancestry and people of a wide range of racial backgrounds had been adopted into various tribes. There were also squatters who knew that the tribal governments could do little to stop them and that the federal government could or would do little about the matter. Over time, groups of these settlers came to feel that they were the legitimate residents of the region and pushed for greater recognition of their interests in Congress, especially regarding the ownership of land. (Courtesy Wichita State University Libraries, Department of Special Collections.)

The cattle business had been central to the region since the time of the Spanish and French. In the mid-1800s, cowboys drove cattle up trails such as the Chisholm Trail to railheads in Kansas and elsewhere. Barbed wire and changing business dynamics ended the great drives by the 1880s, but the area then opened up to vast cattle ranches. (Courtesy Wichita State University Libraries, Department of Special Collections.)

Originally from Kentucky, "Colonel" George Miller (center) started his cattle business in the vicinity of Miami, Oklahoma. Eventually he leased tracts of land from the Cherokees and was influential in the emerging Cherokee Strip Live Stock Association. When the federal government voided those leases and opened the outlet to settlement, Miller leased land from the Ponca just south of Ponca City. The ranch that developed became one of the most famous on the Great Plains: the 101 Ranch.

kAW AGENCY, I. T.

Range on Osage reservation. Horse brand, JF on left shoulder. Some cattle branded F on both sides, some on one side only. Ear marks, crop and under bit in right ear.

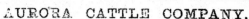

7~ left side

DW right side, CO left hip, large C behind each shoulder and C on left hip.

AURORA CATTLE COMPANY.

Increase brand; As on cut, three half circles on right side; bar (—) on left jaw, and heretofore an upper half crop in each ear, but hereafter a small crop off both ears. Additional old brands: on left side; F V or

The Cherokee Outlet became increasingly popular grazing land for Kansas cattlemen. The Department of the Interior protested this encroachment on Indian Territory (and its authority). In response, several cattlemen formed the Cherokee Strip Live Stock Association. Chartered in Caldwell, Kansas, in 1883, the association obtained a five-year lease from the Cherokee at a cost of $100,000 a year. In time, over 300,000 head of cattle grazed on this part of the outlet. (Courtesy Arkansas City Traveler.)

Farmers and their advocates viewed the outlet as a potential area of agriculture. Some felt that the cattle industry was a corrupt monopoly that made deals with elected officials and tribal leaders. In response, opening the Cherokee Outlet to agriculture would bring in the small farmer who, by the 1880s, blended hard work with the latest technology, such as this steam tractor.

The Chilocco Indian School was opened in 1884, one of many such institutions nationwide established with the goal of assimilating Native American children into white society. In compliance with government orders, the surrounding tribes sent their children to the institution, which remained a significant part of local education for several generations.

The President "...hereby is, authorized, whenever in his opinion any reservation or any part thereof of such Indians is advantageous for agricultural and grazing purposes, to cause said reservation, or any part thereof, to be surveyed, or resurveyed if necessary, and to allot the lands in said reservation in severalty to any Indian located thereon...it shall be lawful for the Secretary of the Interior to negotiate with such Indian tribe for the purchase and release by said tribe, in conformity with the treaty or statue under which such reservation is held, of such portions of its reservation not allotted as such tribe shall, from time to time, consent to sell, on such terms and conditions as shall be considered just and equitable between the United States and said tribe of Indians...." - Dawes Severalty Act, 1887

This excerpt is from the Dawes Severalty Act of 1887.

In booming 1880s Wichita, Kansas, investors and speculators saw their city (and fortunes) tied to the development of what they called the Southwest. Initially reluctant, Wichita business leaders such as editor Marshall Murdock of the *Wichita Eagle* and members of the Wichita Board of Trade became open Oklahomists, supporting development. (Courtesy Wichita State University Libraries, Department of Special Collections.)

Starting in the 1870s, groups of "boomers," such as David Payne, tried to establish settlements in Indian Territory. Payne had been an entrepreneur who sought his fortune with the growing town of Wichita. By the 1880s, however, he had turned his attention south and led several expeditions to found communities in Indian Territory. Each time, U.S. authorities caught up with Payne and removed him, sending him back across the border. Preparing for another attempt, Payne died in Wellington, Kansas, in November 1884. (Courtesy Oklahoma Historical Society.)

By January 1889, over 4,800 prospective settlers had poured into Arkansas City alone, ready to run into Oklahoma. Arkansas City's residents, meanwhile, eagerly anticipated the benefits from the opening. Investors foresaw new financial opportunities. Stores looked forward to new markets and new customers. Local leaders hoped to prosper as the main regional center for the farmers and town builders that would follow.

In the 1870s and 1880s, a handful of vessels attempted to develop river traffic along the upper Arkansas River, including the Arkansas River Navigation Company's towboat *Kansas Millers*. In July 1885, the vessel arrived in Arkansas City and the following year ran tows of barges back and forth to Fort Smith, Arkansas. Despite early hopes for river traffic, railroads proved much more feasible modes of transport throughout the region.

Arkansas City's rival of Caldwell served as the cattlemen's main base of operations, and its leading citizens initially favored keeping the outlet in ranching leases as opposed to settled farms. Even so, Caldwell, like many towns along the border, gained from the influx of boomers. By 1893, it also looked forward to the benefits that would come from future settlement.

The Opening of Oklahoma 1889 "First Run."

With established railroad connections and land office locations, places such as Guthrie hoped to become the region's newest metropolis. On April 22, 1889, a community such as Oklahoma City (seen here below) or Guthrie might go from being a land rush office and railroad stop to a tent city of over 10,000 in one day. (Above, courtesy authors' collection; below, image used with permission of Harper's.)

OKLAHOMA CITY
THE FOUNDING OF CITIES IN OKLAHOMA—From Photographs

What had been unassigned lands became the nucleus of a whole new territory called Oklahoma, created via an organic act of 1890. The act expanded the territory to include the western strip of no man's land, forming what became Oklahoma's distinctive panhandle. The act also anticipated land of the Cherokee Outlet would become part of the territory in due time. (Courtesy Wichita State University Libraries, Department of Special Collections.)

During 1890, the Iowa, Sac and Fox, Potawatomi, and Shawnee ceded their lands for allotment. On September 22, 1891, white settlement began, and the area filled rapidly with towns and homestead applications. The lands of the Cheyenne and Arapaho peoples underwent a similar process, and over four million acres opened to settlement at noon on April 19, 1892. (Courtesy Wichita State University Libraries, Department of Special Collections.)

Pressure to open up the Cherokee Outlet was almost unstoppable. In 1889, Pres. Benjamin Harrison established the Cherokee Commission to facilitate negotiations with the Cherokee to obtain the outlet and open it for settlement. In 1890, Secretary of the Interior John Noble ordered all non–Native American cattle off the land in anticipation of the eventual opening.

The Cherokee Strip Live Stock Association, however, resisted the move and, in a last effort to preserve its interests, offered the Cherokee a tempting $3 an acre. President Harrison, reflecting the attitude of the government, concluded that "the cattle syndicate now occupying the lands for grazing purposes is clearly one of the agencies responsible for the obstruction of our negotiations with the Cherokees."

An economic downturn settled into the country with unemployment going from 3 percent in 1892 to over 18 percent in 1894. The Panic of 1893, as it was sometimes known, saw businesses and banks close in distressing numbers. Strikes paralyzed the nation. Meanwhile an agrarian movement known as Populism swept the plains in the early 1890s. Seeing farmers as the backbone of society, the movement's leaders hoped to improve the farmer's situation through curbing railroads and banks as well as using both silver and gold (a concept called bimetallism) to support currency. (Courtesy Wichita State University Libraries, Department of Special Collections.)

The depression of the 1890s impacted the entire country. Cities like Wichita saw their economic investments plummet. Many in the rural areas found their already marginal situations made even worse. For those with limited alternatives, the promise of a new start in Oklahoma Territory was all but irresistible. (Courtesy Wichita State University Libraries, Department of Special Collections.)

The Cherokee Strip Live Stock Association was disintegrating almost as fast as its relations with the Cherokee. The Cherokees needed the permission of the federal government to dispose of land, and federal officials thwarted any potential arrangement with the cattlemen. With few alternatives available, the Cherokees ceded the outlet to the federal government for $8.6 million in 1892. (Courtesy Wichita State University Libraries, Department of Special Collections.)

Louis Charles Wagner recalled, "I slept on the ground three nights, or two nights. Then on the third day, just before noon, we got all our papers fixed up. There was an awful crowd there and they didn't have enough people to get them all registered. Some of them stayed all night at two or three places. So early in the morning, I went down and got in line. Along about noon they were ready with the other office, and they broke the line right in two just where I was standing. There were only one or two ahead of me. It was only a few hours until I got my registration papers. I didn't care so much whether I got land or not. I didn't have any money . . . but I wanted the fun of it anyhow."

Two

GET READY, GET SET

In March 1893, Congress approved the Indian Appropriation Bill providing for the sale of the Cherokee Strip to the federal government. In August, Pres. Grover Cleveland made his proclamation fixing the date of the opening for the land run. It would become the largest land run in American history.

While the 1889 rush took place during a glorious spring, the 1893 rush unfolded toward the end of a sweltering, drought-plagued summer. To avoid the mayhem of the Oklahoma land rush of 1889, there were many rules governing this event, such as the exclusion of participants who had been in previous land rushes. Before individuals could participate in this land run, they had to register at one of nine places with a registration booth. Here their name was checked against past land rushers and a certificate issued indicating their right to participate in the upcoming land rush. The cost for registration was $14.

"We were in that line from Sunday morning until three o'clock Wednesday evening before we got to the registrar, and we did not leave it, night or day, for fear of losing our places. By turns, one of our number would carry food and drinks to the others. After we had registered, we went back to our camp at Arkansas City for a much needed rest," recalled B. L. Long in *The Last Run*.

The designated towns where one registered became the jumping off points for individuals seeking land in the Cherokee Strip. In Kiowa, Kansas, some 10,000 to 15,000 people camped around this small community. Farther east, in Caldwell, Kansas, another 15,000 potential homesteaders congregated. The largest concentration of land seekers was in Arkansas City, Kansas, with over 65,000 people. Nicknamed "Ark City," the community had two registration booths. Meanwhile along the outlet's southern border, another 15,000 to 25,000 people gathered around Orlando, Oklahoma Territory, with a smaller group in Stillwater. A total of 115,000 people registered for the land run. Including family members, there were probably close to 150,000 participants. There were only 42,000 claims to be made.

To enforce the rules of this land run and to keep people out of the Cherokee Strip until the opening, the military stationed troops throughout the strip. The best-laid plans, however, always seemed to fall apart. In Orlando, the registration booths were robbed of the certificates and official stamp the night before the run, and thousands of forgeries were available for purchase the next day.

Prior to the strip being opened for the land rush, cattle ranchers used the area for grazing cattle. In order to prepare for the run, the military had to remove all the cattle from the region.

Many of the members of several outlaw gangs in the region worked on the ranches prior to losing their jobs because of the land rush. Bill Doolin and most of his gang were among ranch hands such as these.

After the ill-fated bank robbery attempt by the Dalton Gang at Coffeyville, Kansas, on October 5, 1892, the surviving Bill Dalton, along with Bill Doolin, formed the Doolin-Dalton Gang and continued to terrorize the area. On September 12, 1893, the *Guthrie Daily News* noted, "There seems to be a well-authenticated rumour in the city [Guthrie] that the Ingalls bandits [Doolin-Dalton Gang], and other ruffians joined with them, will make an attempt to loot the town on the day of the opening of the strip. These ruffians believe there is good 'loot' in the bank, and that the private houses of our citizens will bear profitable inspection."

THE NEW LANDS

The President's Proclamation Opening the Strip Issued this Afternoon.

The Rush for Homes in the New Country Will be Made September 16, at 12 O'Clock.

The *Wichita Beacon*, on August 22, 1893, noted, "On 19 August 1893, President Grover Cleveland signed a proclamation to open up the lands known as the Cherokee Outlet or Strip. The proclamation laid out the boundaries of the lands to be opened up for homesteading and provided the guidelines for obtaining certificates, filing for land claims, and the payment process." (Courtesy Wichita Eagle.)

Surveying was a complicated affair involving a team of about a half dozen individuals. Some were involved in establishing straight lines by aligning markers with the help of a transit. Others pounded stakes or cleared brush when needed. (Courtesy Tamara Weihe.)

Survey work could be hot, dusty, and dangerous. This first group of surveyors to work in the Cherokee Strip was ambushed and killed by Native Americans.

Before one could participate in the run, the potential homesteader had to register. Nine booths were established along the northern and southern borders of the Cherokee Strip. Five of the booths were in Kansas—Kiowa, Cameron, Caldwell, Hunnewell, and Arkansas City—while four were in Oklahoma—Goodwin, Hennessey, Orlando, and Stillwater. Inside the strip were four claim offices at Alva, Woodward, Enid, and Perry. After staking out one's homestead, the settler went to one of these land offices to file his or her claim. The entire strip was not open to the run as land was set aside for members of the Cherokee Nation, Camp Supply, the Chilocco Indian School, and other public uses such as courthouses, colleges, schools, and parks. (Courtesy Craig Torbenson.)

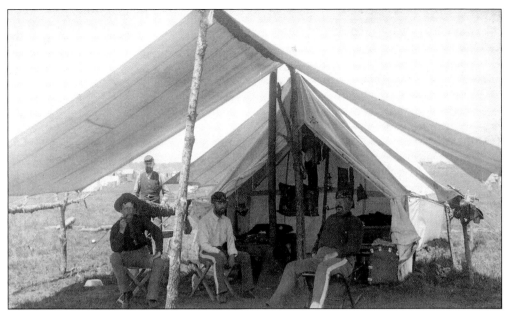

In *Exciting Adventures Along the Indian Frontier*, William R. Draper recalled, "The biggest fuss and furor was with the soldiers, who patrolled the line between Kansas and the Strip, trying to prevent 'sooners' from crossing before the official opening date. Once, while we waited for the official opening day and hour, I saw a soldier shoot a 'sooner' from his horse as he rode across the border. This caused a riot in the camp and the soldier was badly mauled."

Clyde E. Muchmore recalled in *The Last Run*, "As boomer camps cropped up, all summer long blue-coated soldiers patrolled the border. They were under orders to keep out all persons, and as the hour approached they tried to enforce orders strictly. Frequently these soldiers would visit our little town of Kiowa, just a mile and a half from the border, and there they enjoyed along with the cowboys and others the entertainment provided by eight saloons."

In *The Last Run*, Clyde E. Muchmore recalled, "All during August covered wagons moved in along highways. The wind was blistering hot, sweeping in across parched prairies. The coming of September failed to bring the much-needed rain. The sun continued to beat down and the dust became thicker, as those preparing to make the run powdered the roads with constant travel. But even the heat could not check suppressed excitement."

Wagon trains were themselves mostly anachronisms by this time, with railroads being the common way to travel long distances. The boomers and their covered wagons were sources of curiosity and excitement for local families. Sometimes the "movers" simply asked for a place to stay or some water for their horses and themselves. Children who grew up in the area remember fondly hearing stories around the campfire from these latter-day pioneers.

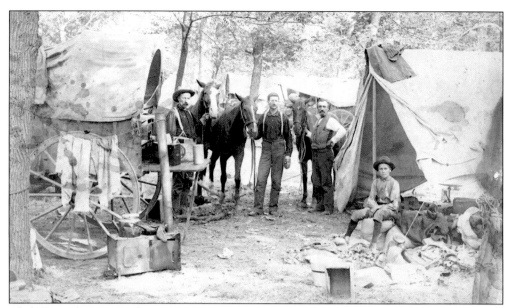

Clyde E. Muchmore, in *The Last Run*, recalled, "By the first of September, 1893, towns were already filled. But still they came, individuals and whole families, by train and by wagon, buckboard and cart; came with their horses, their cattle, their chickens and the inevitable dog; household goods crowded into wagons, farm implements tied along side; came to take up residence in a new land." (Above, courtesy Oklahoma Historical Society.)

Emily Hyatt remembered, "I remember the hospitality of the Arkansas Cityans who opened their homes to the strangers waiting to make the run. The great need for the transients was water. As there were no accommodations for such a mob, the townspeople put pallets and cots in their living rooms, dining rooms and halls to accommodate everyone they could. We were out of everything when the run finally started."

In *The Last Run*, W. A. Bruce recalled, "While camping in our friend's yard, we would take turns watching our teams, wagons and provisions. The night before the run it fell my lot to be watchman. I was laying under the wagon. All at once I heard a noise. Looking around I saw a man sneaking towards our horses. What did I do? I grabbed my forty-five Winchester and in no time had it shoved in his ribs. 'What are you doing here?' I asked. He said, 'I am looking for the registration booth.' 'You are looking for our horses, I know, and you better be going while you are all together,' was my reply. In a flash he was away."

On September 15, 1893, the *Wichita Eagle* reported, "Parties who came up from the strip last night said that the country is filling up with sooners to an alarming extent. The story goes that every night familiar faces disappear from the various camps and are not seen any more. The supposition is that they go into the strip under the cover of darkness and travel until daylight when they hide in some timber within a reasonable distance of some townsite or choice claim from which they will emerge in due time Saturday afternoon and make enough of a run for the townsite or claim they propose to occupy to put their horses through a good sweat. It is probable that some of them will not emerge from their hiding places till others have passed them and they will come out and with their fresh horses beat those who run from the line and at the same time have their victims as witnesses that they passed them on the road, if ever they should be arrested. United States court officers estimate that fully 1,000 people will go to the penitentiary as sooners from the Cherokee strip within the next two years." (Courtesy Wichita Eagle.)

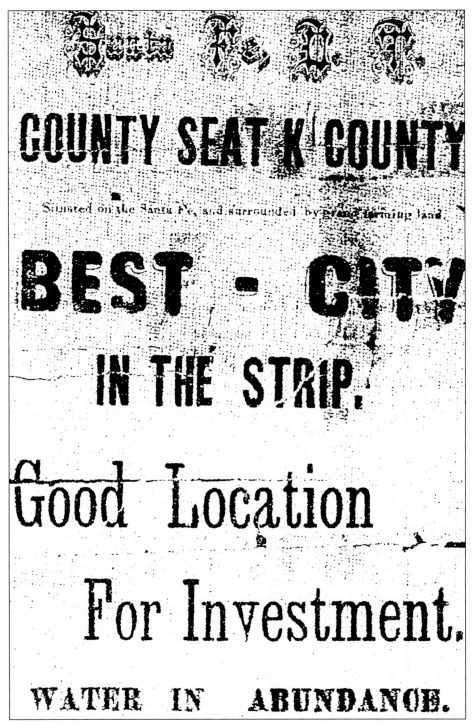

Santa Fe D.T.

COUNTY SEAT K COUNTY

Situated on the Santa Fe, and surrounded by prang farming land.

BEST - CITY

IN THE STRIP.

Good Location

For Investment.

WATER IN ABUNDANCE.

To facilitate the run, the strip was divided into counties with the alphabetical labels K, L, M, N, O, P, and Q along with the establishment of county seat locations. These counties were later named Kay, Grant, Woods, Woodward, Garfield, Noble, and Pawnee. Advertisements such as this, from the *Santa Fe Times*, made interest in the run even stronger. (Courtesy authors' collection.)

W. E. Knapp recalled in *The Last Run*, "On Monday, we went to the tents where the registering was taking place and got in line. There were three tents and a line formed for each tent. I think we were numbers 44 and 45 in the line, where we stayed all night lying on the ground. The next day the crowd began to grow and I could see that we had lost ground in line until we were numbers 246 and 247 now! By this time the dust was three or four inches deep and we were all plenty hot, so we organized in companies of ten with a captain for each ten and this way we began gradually to gain again. The hacks kept coming out from Arkansas City bringing load after load of people and raising the dust, which blew directly on us until we got enough and began throwing watermelon rinds at them."

On September 14, 1893, the *Wichita Daily Eagle* noted, "8,000 people in line at Ark City. 2,000 people arriving each day. The Santa Fe will run six trains for the boomers on the Ark City line. Three will start this side of the line and three from the Oklahoma side. On the Kiowa line one train will be run in each direction. The Rock Island will run six boomer trains south from Caldwell and three north from Hennessey. These trains will be used mostly by those going to the townsites."

In *The Last Run*, John S. Burger remembered, "This registration required approximately two weeks and had attracted people of every race and color, of every occupation, legal or illegal, and of every nationally, a cosmopolitan group that was to be the first settlers and residents of this land. There were farmers, merchants, bankers, ministers of the gospel, lawyers, doctors. There were horse thieves, bank robbers, murderers, and every type of criminal."

D

CERTIFICATE.

CERTIFICATE that must be held by party desiring to occupy or enter upon the lands opened to settlement by the

Presidents Proclamation of August 19, 1893, or the purpose of making homestead entry or

filing a soldier's declaratory statement.

No. *4096*

Booth in *Ark City Kans # 9*

Sept 15 1893.

This certifies that *Bint Smith*

has this day made the declaration before me required by the President's Proclamation of August 19, 1893, and he is

therefore, permitted to go in upon the lands opened to settlement by said proclamation at the time named therein

for the purpose of making a homestead entry or filing a soldiers declaratory statement.

It is agreed and understood that this certificate will not prevent the district land officers from passing upon

the holder's qualifications to enter or file for any of said lands, at the proper time and in the usual manner, and that

the holder will be required when he makes his homestead affidavit, or, if a soldier or a soldier's agent, when he files a

declaratory statement at the district office, to allege under oath before the officer taking such homestead affidavit, or

to whom said declaratory statement is presented for filing, that all of the statements contained in the declaratory

made by him, upon which this certificate is based are true in every particular.

J. C. Lindsay

Officer in Charge.

This certificate is not transferable. The holder will display the certificate, if demanded, after locating on claim.

About obtaining homestead certificates, on September 16, 1893, the *Wichita Daily Eagle* wrote, "The booth in town was besieged all day. Double lines were formed, each containing about 5,000 people. The line was divided into squads of twelve men each, and two squads were admitted to the booth at a time. In this manner they were turned out rapidly. At 6 o'clock 8,300 certificates had been issued, but the lines still contained fully an equal number of men. The booth will be kept open all night." (Courtesy Lynn Smith.)

Floyd C. Allen wrote in a letter to his parents, "I'll tell you this standing in line was no funny job although we had lots of fun out of it. Everybody seemed to be in good spirits in spite of the burning sun and dust which came in such clouds that at times you could hardly see three rods distance, but the prospects of getting a quarter section of land made them feel jolly. We lay in line, or rather stood or squatted or sat flat down on the ground and let our feet hang down for about 36 hours, then came our time. Went through the mill, entered at the east, signed our names and passed out the west door."

Clyde E. Muchmore recalled in *The Last Run*, "The hour was approaching. The line involuntarily tightened up. A shot was heard. The line surged forward as a unit and then began to expand, as slow equipment gave way to fast. Men on horseback took the lead with light carts close behind. Then came buckboards, buggies, spring wagons and farm wagons, all hurtling forward over the bumpy virgin prairie at top speed. There were even men afoot, who hoped to get the close-in claims. In a remarkably short time the line now stretched to the width of two or three hundred yards, disappeared in the distance."

Three

Go!

With a *bang* at noon on September 16, 1893, the race was on for what would be one of the last land rushes in the United States. While in most places the start went without a hitch, in Arkansas City, a shot was fired at 11:49 a.m. leading to a stampede that the soldiers were unable to stop. A similar false start at Hennessey was brought under control by the soldiers, although a few land seekers kept going.

Estimates vary as to how many land rushers actually participated in the run, but it seems that some 30,000 to 50,000 made the run from Arkansas City; 15,000 from Caldwell; 25,000 from Orlando; 10,000 from Hennessey; 7,000 from Stillwater; 10,000 from Kiowa; 3,000 from Hunnewell, and from 5,000 to 6,000 from other locations.

The chaotic scene of the rush has been described in a variety of different ways, but none more clear than the following, taken from the *Guthrie Daily News* on September 17, 1893:

> When the signal sounded at Orlando and the crowd, like a mighty torrent, burst over the line into the land which to them had been so long a mystery, there went to the skies a roar so far reaching and prolonged that the very sense of hearing was stunned and the faculty of thought for the time seemed paralyzed. I have heard the roar of artillery—sixty batteries playing on the enemy at one time have listened to the federal yell and rah coming up from 50,000 soldiers' throats, have listened to the fiercest peals of thunder as it rattled amid the lonely pines of the Black Hills . . . but never in all my life did I hear a cry so peculiar—a roar of such subdued fierceness like to the awful agony of a mighty ocean in the storm throes of madness as that which rose on the morning air that fateful day of September 16, 1893. It seemed to me as if all the mad passions of an army of devils was let loose . . . and in dense and horrid clouds of sand and dust, were sweeping down upon some world upon which they had planned to wreck a dire and awful vengeance.

On September 17, 1893, the *New York Times* noted, "For an hour before, the borders of the Strip were black with men, horses, and teams. From the elevation at Orlando the line could be seen for a distance of eight miles east and ten miles west. In each direction the line was crowded until there appeared but a black ribbon outline on the gray surface about them. Half a dozen times someone would shout the hours of noon and 50 to 100 horsemen would draw out of the line, only to be driven back by the cavalrymen who were patrolling the Strip in front of the impatient throng."

In a letter to his parents, Floyd C. Allen wrote, "When we were cut loose the wagons, carts and buggies generally formed a line back of the horsemen, but here they were a solid mass along the entire line. Only five minutes someone shouts until we start. Now the horsemen line up as close to the hundred feet line as they dare to. Every man with team gets his lines and holds his whip ready. Two minutes to twelve everything is as quiet as a graveyard, not a word is spoken by anyone, even the horses seem almost to have stopped breathing, everyone leaning forward for the signal that would send them out on their wild chase."

Sarah Hall, in *The Last Run*, recalled, "The farmer hitched up his wagon and with his family and I drove into his back pasture where we could have a clear view of the famous 'run.' It was a sight not to be forgotten. Cimarron was a true and accurate picture of it all. I remember how straight the line was, how many different kinds of vehicles there were, and every kind of horse—in fact, anything that was able to travel was lined up for the starting signal. Even the hounds were imbued with an excitement past their comprehension, and kept up a continuous yapping which added to the general confusion." (Below, courtesy Oklahoma Historical Society.)

In a letter to his parents, Floyd C. Allen wrote, "Had our horses pretty well loaded down for running, had about six quarts of oats and grub enough to last us about four days stashed on back of saddle. Also had our canteens filled with cold tea which held 3 quarts, which we carried on our right sides. I also had heavy colt revolver strapped on my right side. This was about the appearance that most of the horse backers made as we rode down to the line. We could hardly decide just where to start from as there was no thin place in the line."

In *The Last Run*, Mrs. J. P. Souligny recalled, "Tense with excitement we saw people dashing away all around us, with our mules lunging and my sister-in-law holding the bits and waiting to hook the other traces. I held the lines and watched the minutes on my watch go by, impatient to follow the other eleven of our party." (Courtesy Oklahoma Historical Society.)

O. J. Devore, in *The Last Run*, remembered, "In order to avoid that awful dust west to Arkansas City, we just mostly kept out of the way of people the best we could, this was in the race and that's why I started from there. There was a new fence around this lease and we didn't know what they were going to do about it the morning of the race. At ten on the morning of the run came a suggestion from the Secretary to cut the fence every twenty rods and put the people through prior to the opening. There I was, one and one-half miles west of the Northwest corner on a hill. I figured where my claim was, and I had counted eleven hundred revolutions, and hands down I would have my land!"

In *The Home Missionary*, January 1894, Rev. J. H. Parker recalled, "The Opening of the Cherokee Strip" "The horsemen and those in light vehicles were lined within a hundred-feet strip along the border for miles, and the heavier teams, loaded with merchandize of all sorts—lumber, household goods, tents, buildings fitted and ready to be put together, barrels of water, stacks of cooked food, etc. etc.,—were arranged in the rear to follow the owners, who were to race for claims and town lots. On the railway there were forty palace stock cars attached to three engines. As this train moved into position it was literally filled and covered, sides and top, with living humanity as fast as men and women impel by the wildest frenzy could scramble into place."

On September 17, 1893, the *New York Times* noted, "The trains filled rapidly. At first there was an attempt to examine the registration certificates, but this was soon given up as the rushing thousands pushed those ahead of them, the trainmen giving all their time to collecting tickets. The first train of twelve cars pulled across the line at noon, crowded as trains never were before. Platforms and roofs of cars were as black with human life as were the interiors." (Courtesy authors' collection.)

Floyd C. Allen wrote in a letter to his parents, "All of a sudden someone shouts 'there they go' and glancing up to the east about a mile distance on top of a raise we could see a perfect cloud of dust. This was the only signal we had. So away we went. It looked like a mighty army moving off at a rapid speed as far as the eye could reach east or west. It was one solid moving mass."

William R. Draper recalled in *Exciting Adventures Along the Indian Frontier*, "When the gun cracked and the race began . . . our mules stood still. Father began swearing . . . and striking them with the long blacksnake whip. The louder he swore and the harder he struck the mules, the less they moved. Mother jerked the whip from father. While thousands moved ahead our mules continued to balk. It was an agonizing half hour, with our golden opportunity gone glimmering. Then we found ourselves all alone on the prairie, not even a soldier in sight. We were 200 feet north of the border. In the turmoil and the excitement the home seekers had rushed away and off to the south, neglecting the farms which lay immediately adjacent to the border. Father was quick to see it. He jumped out of our wagon and started giving orders."

ACCIDENTS WILL HAPPEN.

An article in the *Wichita Sunday Eagle* on September 17, 1893, contained the following: "Farther on two men jumped from the train . . . both intent on staking a bit of beautiful land beside the tracks. They had not seen each other until they reached the barbed wire fence which shut off the railroad's right-of-way. It was there the fun began. One attempted to climb over, while the other hoped to squeeze through. The fence was tough, but finally the squeezer went through and while his rival had achieved the top, a most savage barb caught and held him there. The other man drove his stake and returned to give the poor fellow a lift." (Courtesy Wichita Eagle.)

On September 19, 1893, the *Wichita Eagle* reported, "He was pumping his bicycle for dear life, but was sandwiched in between a half dozen covered wagons and every time a horse's hoof struck the ground it would throw somewhere in the neighborhood of a pint of dust in the professor's face." Note the advertisement for land rush maps just below this bicycle advertisement. (Courtesy Wichita Eagle.)

'The whole scheme by which this land was opened ha
aided, intentionally or not, the gambler, the adventurer, an
he dishonest speculator. Fraud, bribery, and false swearin
have been the rule from the beginning, and I fear, continu
o govern too much among the smaller and larger official
Hundreds of thousands of dollars have been expended b
he Government and by the people worse than uselessly
and scores of lives have been sacrificed in the rush. Som
of the scenes of that afternoon were ludicrous and som
pathetic. Thousands of men, and some women, jumped c
rolled or fell from the trains, moving at the rate of twelve c
ifteen miles and hour, to secure a claim or a lot. Som
broke an arm, or a leg, or both; a few were killed, but th
majority escaped with no serious hurt. Many got more rea
estate upon their faces and persons than they had to keep c
sell that night."

This text is excerpted from "The Opening of the Cherokee Strip" by Rev. J. H. Parker. It was
published in *The Home Missionary* in January 1894.

The son of New England missionaries, Rev. Joseph Homer Parker, shown here with his family, came to Wichita in the 1880s. While there, he worked to create an institution that eventually became Fairmount College, today's Wichita State University. When the building program of the school halted during the economic decline of the late 1880s, Parker turned his sights south and relocated to Oklahoma shortly after the 1889 rush. He became superintendent of public instruction and auditor, worked to establish Congregational churches in Oklahoma, and was a major force behind the creation of Kingfisher College. Parker witnessed the 1893 rush trailing behind the main onslaught in a buggy. (Courtesy Wichita State University Libraries, Department of Special Collections.)

Margaret Hudson Kirkpatrick remembered, "I had been instructed if a prairie fire should be coming toward me, to set fire to the grass, for a backfire, and to burn off a space on which my pony and I might stand in safety. I was fortunate in having had such good advice. Two men set fire to the prairie grass, in an apparent effort to run me off my claim, but, following my father's instructions, I immediately set out a backfire."

In *The Last Run*, Dick Sherbon recalled, "Alfred was racing down across the plains, when the fire that had been started behind the racers, was gaining fast. Dismounting from his horse, he burned a spot big enough for him and his horse to stand in before the greater fire reached him. The fire burned high and fast, sweeping the plains, gaining on the runners, burning many of them alive, suffocating them with the smoke and smothering them with the heat. Alfred barely escaped with his horse as the fire subsided as quickly as it came."

Charles Tunis Dodrill remembered, "There was a score of people for each available plat of land. Like the previous runs, the 'sooners' were on hand to pre-empt the claims of legitimate participants. There was a massive scramble for the establishment of claims. There were fights and even murders. The crowds were beyond all expectation. None of our family was able to stake a claim and we returned to our homes tired, forlorn, and disappointed land seekers. At least, we had much fun in watching the scramble for position." (Courtesy Wichita Eagle.)

Flora Hight remembered, "Our father was gone several days and didn't even wash his face while down there. There was no water to wash with, hardly enough to drink, no clean place to eat, no place to stay. Perry was just a town of tents with no accommodations for the crowds which thronged there to register claims. My father was not so lucky as someone had filed a prior claim to his plot."

B. L. Long had the following account appear in *The Last Run*: "After dinner we started to Perry to file notice of our claim. On Tuesday we were given a number in the line and notified that it would be thirty days or more before we could file, so on Wednesday we started back to New Salem." (Courtesy Oklahoma Historical Society.)

Thomas Burns, in *The Last Run*, recalled, "A Town Site Company was formed where Ponca City now stands. Lots sold for $2.00 per lot. Everyone immediately staked his claims, then went down to Perry to the Filing Office where claims were filed at a cost of 14 dollars. Six months time was given for improvements. A person must live on the claims five years before proving up and pay to the government $2.50 per acre."

Pictured here is the last remaining land office (restored) in Enid, Oklahoma. It is located at the Museum of the Cherokee Strip. (Courtesy Tamara Weihe.)

This is an interior view of the land office in Enid, Oklahoma. (Courtesy Tamara Weihe.)

HIS IS THE ONLY REMAINING UNITED STATES LAN
OFFICE FROM THE SIX OKLAHOMA LAND RUNS
889-1896) AND OTHER OKLAHOMA LAND OPENING
THIS OFFICE WAS BUILT IN ENID FOR THE
REGISTRATION OF CLAIMS IN COUNTY O, LATER
NAMED GARFIELD COUNTY, FOR THE LAND RUN IN
THE CHEROKEE OUTLET ON SEPTEMBER 16, 1893.
IT WAS MOVED TO THE HUMPHREY HERITAGE
JILLAGE AND RESTORED BY THE HERITAGE LEAGU
THE CHAMPLIN FOUNDATION AND THE OKLAHOM
HISTORICAL SOCIETY.

MARKER DEDICATION FEBRUARY 21, 1997

OKLAHOMA SOCIETY
ATIONAL SOCIETY COLONIAL DAMES XVII CENTUR

This is the land office plaque at the Museum of the Cherokee Strip in Enid, Oklahoma. (Courtesy Tamara Weihe.)

Joe Milam wrote in *Chronicles of Oklahoma*, "The center of interest in each town was the land office, where the rate of filing averaged around a hundred a day. Wisely profiting by their experience at the registration booths, deputy marshals who had charge of the lines, gave numbers and took names of those wishing to file, lines being formed in companies of 100 each. This rule met everywhere with commendation, for by it, claim holders were able to tell, almost to a day, when their turn would come." (Image used with permission of Harper's.)

Even before the 1893 run, the chaos, turmoil, and violence of the rushes made government officials start reconsidering the whole land distribution process. The last run took place on Kickapoo lands in 1895. Later lands usually opened up through a lottery system. For example, in 1906, lands in a parcel called the Big Pasture in southern Oklahoma were sold to the highest of sealed bids. Among the lands in the Big Pasture were the Wichita Mountains, shown here. (Courtesy authors' collection.)

The rush of over 100,000 settlers into the Cherokee Strip in a single day created new farms, towns, and industries literally overnight. There was a period of chaos as clashes and rivalries over land were fought both in court and out, often ending in violence. Essential to the growth and development of the region were the railroads, the cattle trade, and oil. After successfully staking a claim, rushers had to go to one of several land offices to register before they could start developing their land. (Image used with permission of Harper's.)

Four

STARTING OVER

After the run is over; after the dust is settled; after the excitement subsides, then comes the stern, hard prosaic life of the pioneer that converts the virgin soil into well tilled farms, and the wild and wooly towns into peaceful and order loving communities. Realization will fall far short of anticipation. But the die is cast and those who possess the nerve and sand to endure the hardships incident to the settling up of a new country will in a few years become the solid men of their locality.
—*Wichita Daily Eagle*, September 17, 1893

By the end of that hot, dusty day in September 1893, whole towns had sprung from the prairie, and the beginnings of farms were starting to take shape. Lucky rushers did their best to protect their claims while registering at the nearest of the four land offices. The unfortunate headed back to points of origin or just settled in existing towns along the border. A number continued to move west, founding communities in western Kansas and the Oklahoma panhandle.

Some rushers were injured in the run, suffering from broken bones, heat exhaustion, or burns. Others had to bury those trampled in the onslaught of the crowd. Some died in the quest for a new life in a new land. Those who were lucky enough to stake a claim began the necessary tasks of building a shelter and stocking up enough food to last through the winter. For many that meant getting a crop of turnips in the ground before frost and carving a home from the earth so that they could stay warm by the time the first snow fell. Conditions in the first months after the land run were tough; it had been a hot, dry summer, water was limited, and there was still an air of lawlessness with cattle rustlers and dejected rushers stirring up trouble. Those who stayed had found their challenges just beginning.

By the beginning of the 20th century, however, the towns and farms created from the land rush were booming centers of commerce. The discovery of oil created a drilling frenzy that brought a new wealth and excitement to the land. The landscape changed once more to include the sight of looming oil derricks, pumping liquid gold from the earth. Getting to this point took a lot of grit, guts, and determination.

After the dust settled, land rushers put up tent shelters to protect them from the scorching sun. For days after the run, dejected rushers attempted to steal land, and land speculators tried to accumulate as much land as possible. New landowners sometimes had to resort to violence to protect rights to their claim.

Rushers had to make improvements on the land, prove that they were not sooners, show that they had the only claim on the land, and not leave the land for more than a period of six months. Improving the land also required surviving on it. Due to the lack of building materials such as lumber, lucky landowners had to quickly carve a home out of the earth before winter. Many sod homes, such as the one pictured here, were literally built out of the land.

Many crimes were reported and most were unsolved, largely due to the lack of law enforcement. The United States military and local law enforcement drastically underestimated the amount of people that would participate in the rush and were overwhelmed with these crimes. Many criminals took advantage of the often unarmed and unprepared women and children left to hold the claim. Many rushers took the law into their own hands.

A sooner was a rusher who went into the territory before the starting gun or left from a town on the fringe of the territory that was not a designated jump-off site. The 3rd Calvary of the United States Army commenced a search throughout the territory seven days after the rush, pushing sooners out of the territory and making a search for rushers who did not make the rush from an official town site. (Image used with permission of Harper's.)

Once supplies arrived, settlers began to build more permanent structures such as the frame home pictured here. In the pioneer interview collection at the Oklahoma Historical Society, Ruby Hoggs recalled, "We then returned to Kansas where my father completed arrangements for moving his family, household goods, and stock to the new location. He erected a two-room plank house in which we lived for three years. His intentions were to establish a dairy on a large scale and he had taken his dairy herd with him. But after some three years time, he decided to change locations and secure a larger acreage."

A house was necessary to protect settlers from the elements. One of the first tasks performed was planting late-summer crops to survive the winter. For some, hunting was necessary to supplement a meager diet of root vegetables. Here Joe Gibson and his family show off a fine catch of rabbit. (Courtesy Betty Jo Scott.)

The soil in the territory was often not the best. Many families resorted to growing vegetables that did not need a lot of care and could be kept from the elements. This was largely due to long droughts and bad winters. After many years of cultivating the land and with new farm technology, however, the rushers turned this once barren land into productive farms.

Several years after the rush, scenes such as this were commonplace. The land was starting to produce crops not only for the rushers' families, but enough to make a living farming. The progress made was shown by the determination of the rushers, and the payoff was immense.

With severe drought before the race, water was very scarce in the new territory, and many rushers suffered from dehydration. There were pockets of relief. Three days after the beginning of the rush, the township of Alva hit crystal clear water, and immediately five such wells were built to relieve the distressed boomers. Six days after the beginning of the race, the heavens opened up, and settlers were treated to a welcome downpour.

Rain produced its own problems. In the lower-lying lands of this new territory, flooding was inevitable. Many people were driven out of their homes near the rivers when they flooded. Above, folks gather to survey the damage.

The most frightening disaster in the territory was prairie fire. Severe droughts in the territory made the land prime for spreading such fires, and since there was no hope of stopping the blazes themselves, the rushers could only pray that the fires would miss their homes or that the fires would die down. Fire was natural to the area and burned off last year's grasses for a new growing season. In time, fires on the land were not disasters, but were signs to a farmer of the rebirth of the land. Many farmers burned their fields after harvest to kill weeds, bugs, and other parasitic organisms that might keep the land from reenergizing itself. (Image used with permission of Harper's.)

Cattlemen who were still grazing their cattle on the plenteous grasslands resented the coming of the "nesters," as homesteaders were called. Cattlemen who had leased the lands from the Native Americans prior to settlement believed that they were the legitimate users of the land. They were outraged when the land was scoured by plows and fenced off by barbed wire. Cattlemen sometimes

punished the homesteaders with violence, including the burning of houses. Stampeding cattle destroyed growing crops. Some homesteaders, however, chose to raise cattle instead of farming, making the cattle industry still one of the most lucrative commodities in Oklahoma.

Pictured here is a section roped off by homesteaders who had staked their claims and had filed at the claim office in Perry, Oklahoma. At noon that day, only the land office had existed; by that night, over 25,000 tents occupied the town, including the infamous Hill Brothers circus tent that sported a saloon in what some called Hells Half Acre.

Many business owners built their establishments and were operational within days of the race. At noon, Enid had one building and four settlers; at 3:00 p.m., it had 12,000 with a hotel and several restaurants. Among the residents was blacksmith Jim Fenlon, who got his start by setting up his anvil in the middle of the town site. Meanwhile John J. Gerlach had a boxcar of goods shipped from Higgins, Texas, within a mile of the land office in Woodward. Shortly afterward, he opened a bank on his lot.

Towns like this sprang up throughout the strip within a month of settlement. One was Blackwell, started by a group of settlers from Winfield, Kansas, lead by Col. Andrew Jackson Blackwell. His Cherokee wife had an allotment that adjoined the town. Isaac Parker, meanwhile, developed a rival across the river about a mile away. When the train ended up being built in Blackwell, however, Parker became a ghost town.

In an account in the pioneer interview collection at the Oklahoma Historical Society, Mrs. S. L. Johnson recalled, "The Government had sent my husband to Alva as postmaster. Mr. Johnson had come down before me with a car load of material to help build a post office. On the same lots were to be a jail and a land office. The furniture for the post office came from the Wichita post office. I was to come down in the run on the Santa Fe train, which had just one car."

Railroads remained an important part of local development. These included the Missouri, Kansas and Texas; the Rock Island, seen here, which ran from Wichita to Fort Reno; the Santa Fe, which extended its line from Arkansas City to Galveston, Texas; and the St. Louis and San Francisco, which ran the length of the territory into Texas. (Courtesy Oklahoma Historical Society.)

In the pioneer interview collection at the Oklahoma Historical Society, Ruby Hoggs recalled, "At that time, in 1894, the Santa Fe Railroad was building through that section of the country and had reached the site on which the town of Alva now stands. My father (Arthur S. Smith) sold his holdings to the railroad company realizing a good price and the Santa Fe depot now stands on the exact spot where he drove the stake on that memorable day." (Courtesy Wichita Eagle.)

The railroads and federal government established town sites and train depots in conflicting areas, resulting in violent acts of desperation by the townsfolk. In Enid, the government had designated the county seat three miles north of the Rock Island depot. As a result, two towns within three miles of each other emerged. Citizens petitioned the railroad to stop in South Enid on its way through but the railroad refused. Out of desperation, the citizens sawed the beams of a bridge, causing the train to crash. Petitions that were sent to Congress to compel the railroad to build stations in areas of dispute had been delayed in the Senate. After the crash, the Rock Island's chief of council advised lobbyists to cease opposition. The bill passed immediately. South Enid received a new depot, and eventually all businesses were moved there. (Courtesy Museum of the Cherokee Strip, Oklahoma Historical Society.)

Cotton in the Cherokee Strip is grown primarily in Kay, Alfalfa, Grant, and Garfield Counties. By 1899, there were 125,000 bales of cotton produced in Oklahoma, bringing in an annual income of $5 million. By 1922, Oklahoma ranked fourth among the cotton-producing states. Shown here is the cotton market in Guthrie. (Courtesy Janet Rhoads.)

Throughout the Cherokee Strip, as soon as the dust settled and claimants had staked their claims, businessmen erected tents from which to sell their wares. Shortly thereafter, they constructed buildings with lumber supplied from the railroads. Many business owners settled near towns with railroad access in order to have stock available to supply their stores. The Buttery Grocery in Enid, Oklahoma, shown here, was one example. (Courtesy Museum of the Cherokee Strip, Oklahoma Historical Society.)

Eugene Watrous was born in Rome, Illinois, on March 31, 1861, and moved to Oklahoma Territory at the time of the rush. He was the proprietor of the Watrous drugstore located at 125 North Grand Avenue in Enid. He was a prominent businessman who helped raise $50,000 for the Enid State School for the Mentally Disabled. He also helped raise $200,000 for other building projects in the city. (Courtesy Museum of the Cherokee Strip, Oklahoma Historical Society.)

Pictured here is an Enid Electric Company serviceman and the electric generator used to power the city. Shortly after electricity became available in the 1880s, cities throughout America adopted the new technology, and communities in Oklahoma were no exception. Stillwater's first electric service was created in 1901. It did have limitations, being available only to the central city and from 8:00 p.m. until midnight. Rural citizens, however, did not have the luxury of electric power until the Roosevelt administration formed the Rural Electrification Administration (REA) on May 11, 1935. The REA allowed financial assistance in the form of governmentally guaranteed loans, for the formation of consumer-owned and consumer-controlled electric companies. (Courtesy Museum of Cherokee Strip, Oklahoma Historical Society.)

John Piper poses with the telephone equipment he operated from the dining room in his home in Douglas. In 1912, the Piper home was strung with a large bundle of wires from a pole set out in front of the house. Daughter Dora was one of the area's first telephone operators. Granddaughter Betty Jo Scott remembers a large rolltop desk with many cubbies that held long-distance charge tickets ready for monthly billings. (Courtesy Betty Jo Scott.)

Without the electric service available in the towns, rural residents relied on gas lamps such as this one for lighting. On January 1, 1900, a lamp salesman in Kingfisher named W. C. Coleman founded a company that originally just serviced lamps. A few years later, he moved to Wichita and founded the company that bears his name. (Courtesy the Coleman Company, Inc.)

Rushers depended on doctors like Henry B. McKenzie, who participated in the land run and settled in Enid. Doctors like McKenzie, who opened the Cherokee Pharmacy, provided homesteaders with medical care and pharmacy needs. (Courtesy Museum of the Cherokee Strip, Oklahoma Historical Society.)

During the 1918 influenza epidemic, which hit communities such as Ponca City, the local chamber of commerce and the municipal authority decided to build an 18-bed facility. The project was financed with the help of E. W. Marland, a Ponca City oilman. He purchased two ambulances and all the hospital equipment at a cost of $30,000. The hospital opened its doors to patients on December 3, 1919. A month later, Marland donated another $20,000, allowing the hospital to double its capacity to 40 beds. (Courtesy Museum of the Cherokee Strip, Oklahoma Historical Society.)

Meanwhile oil derricks like this one started springing up all over the landscape. In August 1889, Edward Byrd drilled the first oil-producing well in Indian Territory. The well was located west of Chelsea, which was then in the Cherokee Nation. It was 36 feet deep, and it produced a half barrel a day. Byrd held an oil lease on 94,000 acres, signed by Chief Bushyhead of the Cherokees. The Department of the Interior questioned the Native Americans' rights to the minerals on their land. So much red tape ensued that Byrd abandoned the wells and moved to Texas.

George B. Keeler, in conjunction with Cudahy Oil Company, began drilling at the north end of the Caney River. In March 1897, the first commercial well in Indian Territory, the Nellie Johnstone, was discovered, gushing at 150 barrels a day. In 1899, the Atchison, Topeka and Santa Fe Railroad opened a depot in Bartlesville, allowing oil to be shipped to a refinery in Neodesha, Kansas, for processing into kerosene and other products.

The wealth that oil brought to the region was incredible. Several individuals, both white and Native American, profited from the industry. Osage chief James Bigheart signed a lease with Henry and Edwin Foster in 1896 to prospect for oil on the entire Osage reservation. After eight years of drilling, it appeared that all their time and money was wasted when H. V. Foster, Henry's son, inherited the lease and made his way to Oklahoma. H. V. Foster organized the Indian Territory Illuminating Oil Company, and in 1906, oil production increased from 20,000 barrels to 641,000. A census for the Osage Nation was enumerated in 1906; all members were entitled to equal shares in the tribal profits, and each of these were known as head rights. Some members of the tribe held up to eight head rights, which brought them an annual income of approximately $100,000.

The land rush helped lead to Oklahoma statehood in November 1907. In the process, Oklahoma City replaced the territorial capital of Guthrie. It was the culmination of a century of white attempts to settle the land. Oklahoma's rich and abundant oil fields were so prevalent that some had oil rigs in their back yards. Even the state's capitol was surrounded by these looming towers of wealth and prosperity. (Courtesy authors' collection.)

Five

FROM OUTLET TO OKLAHOMA

From the beginning, Oklahoma has been a diverse cultural haven for those who have called it home. Native Americans, both those native to the land and those removed to the territory, occupied the Oklahoma prairies for almost two centuries. African American populations immigrated, either as freed slaves or Native American–owned slaves, while most white settlers came as a result of the land lotteries and rushes. The opening of the Cherokee Outlet provided opportunities for immigrants such as Mennonites, who eventually formed communities that shared their faith and values.

In the early years of the territory, two very distinct populations arrived. One came from Texas and was Southern in culture and Democratic in politics. From the north, through the rushes of 1889 and 1893, came waves of Kansans who brought with them Midwestern values and Republican politics. In many ways, the creation of Oklahoma was the last struggle between Northerners and Southerners over who would settle the Great Plains, a struggle that began 50 years earlier with what could be considered the first opening, the Kansas-Nebraska Act of 1854.

On August 21, 1905, the Five Civilized Tribes convened in Muskogee to draft a constitution and organize a government to create a new state of Sequoyah. Delegates were chosen to go to the United States Congress to petition for statehood. Members of the Five Civilized Tribes wanted a Native American state and put their proposal to a referendum that the people supported. In Washington, D.C., sentiment was not favorable to the possibility of admitting two new states. Pres. Theodore Roosevelt, feeling pressure from Congress, denied statehood to Indian Territory, deciding that both territories would be admitted as one state. The Oklahoma and Indian Territories were united by the Enabling Act of 1906, which paved the way for statehood.

On November 16, 1907, Oklahoma became the 46th U.S. state. People had flocked to Oklahoma from all over the world to strike it rich in the oil industry. By this time, show ranches were already big business in the world of the Wild West. Competitions in these shows among cowboys have evolved into rodeos that are still extremely popular among fans today. Cattle continued to be popular as an alternative to farming, and large ranches dotted the landscape between farmlands. Oklahoma was mineral-rich, the fourth in the nation for mineral production.

Creating a governing structure for the new territory was an effort in itself. Florence Louise Hitchcock Burch (in lower right corner), for example, assisted territorial governor George Steele, served as a clerk for the first territorial legislature, and, later, worked in the U.S. marshal's office in El Reno (seen here). Christian Madsen (lower left) served in the Danish and U.S. Armies before coming to El Reno to be deputy U.S. marshal. (Courtesy Janet Rhoads.)

News of Oklahoma's statehood rang out across the region, as this headline from Wichita suggests. Cities like Wichita saw Oklahoma as a natural outlet for investment and commerce. In time, however, oil and other industries allowed Oklahoma to develop its own economic standing. By the 1920s, Wichita found itself competing with booming cities such as Tulsa and Oklahoma City. (Courtesy Wichita Eagle.)

Logan County Court House, Guthrie, Okla.

Guthrie, settled in the land run of 1889, became Oklahoma's first territorial capital, and until June 11, 1910, was its first capital city. Downtown Guthrie has been named a national historic monument because of its commercial architecture. The historic district in Guthrie has over 2,000 historic buildings such as the one above. Built in 1907, the building has classical revival details and was the original state capitol building. The structure now serves as the county courthouse. (Courtesy authors' collection.)

During the 19th century, groups of Mennonites migrated westward, and many eventually settled in Kansas. Upon hearing of the land openings in Oklahoma, some ran for new lands in the 1893 rush. Among their contributions to the region was the introduction of a hard winter wheat. Mennonite churches spread widely across the Cherokee Outlet from Lookout in the northwest to Fairview and Perry in the south to Newkirk in the northeast. (Courtesy Sharon Hartin Iorio.)

Settlers in Oklahoma Territory may have lived in sod houses, but for this photo opportunity, their most important possessions were in the shot, including the barn, animals, and family. In this 1919 photograph, Joe and Dora Gibson, together with their children and belongings, represent the result of hard work, perseverance, and dedication to God and country. Gibson's daughter, Betty Jo Scott (née Gibson), said her father even made brooms in the barn from broom corn grown on his claim. (Above, courtesy Betty Jo Scott.)

Starting with soddies, shanties, dugouts, or framed shotgun homes, some farmers even upgraded to popular Victorian-style homes, such as this one, as they prospered. Some of these homes were prefabricated kits that were easily built by the homeowner and reflected pride in home and community and a desire to keep up with the latest eastern trends. Railroads played an important part in bringing these kits from factories in the east. (Courtesy Donita Neely.)

The outlet spans what meteorologists now call Tornado Alley. A tornado that hit the west side of Ponca City on April 25, 1912, destroyed many homes and killed one person.

In days when homes were still lit by gas or coal and many items were made out of wood, fire was a constant threat in town life as the 20th century dawned. Fire destroyed a good portion of Newkirk in 1901. Both types of disasters caused considerable damage in growing towns in the early 1900s. Towns with a strong sense of community and thriving economic base were able to recover from disasters such as these and others and continue to grow and flourish.

Some of the many towns settled in the run experienced very little growth. Some even dissolved. This sleepy little town with a population of just under 300 residents remains a small haven for those who live there. This was usually due to one or several factors, most prominently the lack of rail service. Not having a railroad connection to the rest of the region restricted growth and development by preventing necessary commerce a route in and out of the area.

Towns like Enid grew to be large centers for commerce and trade fairly quickly. Streets bustled with activity, and a modern streetcar system provided public transportation for the city's workers.

Within days of the 1893 run, Burton Seymour Barnes, a furniture manufacturer originally from Michigan, and several colleagues began to develop Ponca City into a regional center. It was oil, however, that transformed the community with figures such as E. W. Marland and Lew Wentz among its leading citizens. By the 1920s, its residential, commercial, and civic buildings sported some of the area's most fashionable Southwestern-style architecture, such as this mission-looking city hall. (Courtesy Historic Images LLC—Falconer Collections and Curt Teich Postcard Archives, Lake County Discovery Museum.)

Through good times and bad, businesses served their patrons with their daily needs, providing food, water, clothing, and medical needs. This drugstore in Douglas, operated by H. G. Parker, served its patrons from 1908 through 1957, including two world wars, the dust bowl and depression years, and the growth and prosperity during the post–World War II years. Parker practiced medicine from 1904 until 1962 in the back of the store and serviced pharmaceutical needs from the front. (Courtesy Phillip Moseley.)

Even before the land run of 1893, Oklahoma was preparing for the education of its population. In 1891, systems were developed to fill the need for higher education. At the time of statehood, schools were also organized as state institutions in Indian Territory. Private institutions also provided vocational education, and there were, at varying times, approximately 20 business colleges in the state. Examples of other vocational programs include barber and cosmetology, farming, and homemaking.

City parks and lakes were built to provide citizens with recreation and a place to escape and relax from their daily toils and strife. In rural areas or small towns, the carnival or fair would come for a week and was the highlight of the year. In larger communities, trolley companies placed amusement parks at the end of the line to generate revenue to cover the electric cost. In 1909, for example, the Enid City Railway Company built Lakewood Electric Park on a man-made lake; it eventually had a bowling alley, boathouse, scenic railway, and other amusements. (Below, courtesy Museum of the Cherokee Strip, Oklahoma Historical Society.)

Wild West shows promoted the region's increasingly romantic past. One was Pawnee Bill's Wild West Show in Pawnee, Oklahoma. Meanwhile, on September 16, 1906, the 101 Ranch held a Wild West show to celebrate the 13th anniversary of the opening of the Cherokee Strip. Some 2,000 people took part in the show. Cowboys exhibited rope tricks, bronco busting, and steer roping. Native American men dressed in full regalia, including feathers and paint. Native American women and children were also involved, displaying Native American camp life with tepees, and 50,000 people attended the celebration. The Wild West show became so popular that the Millers took it on the road, and they traveled all over the world.

When Col. Joe C. Miller moved onto the Oklahoma plains, he and his sons lived in a sod home carved out of the earth. In time, his 101 Ranch grew in size and scale. Unfortunately Miller did not live to see the grandest house finished, dying of pneumonia in 1903. This building resided on the prairie for over 100 years, but, sadly, it was damaged by a tornado and was torn down.

The Millers of the 101 Ranch organized the Cherokee Strip Cow Punchers Association in 1920 for the purpose of bringing the cowboys together. They met annually on Cowboy Hill at the 101 Ranch. The organization included anyone that had been a part of the cattle industry in the Cherokee Strip during the time period from 1874 to 1893. At one time, there were about 400 members. The organization functioned until 1958.

In *Then Came Oil*, Lon R. Stansberry noted, "We old timers think of its wonderful prairies, its magnificent hills, and the creeks of cool sparkling water filled with perch, crappie and black bass; but today its plains are dotted with oil derricks, the grass is covered with oil, the beautiful streams are filled with salt water and fish have long since been strangled out. The black walnuts, the beautiful elms, redbuds and cottonwoods are all dead, and the great bluffs and rocks are now black with oil. The pump house stands on the old round-up grounds. The old 'snubbin post,' where many a bronco first felt the cowboy's rope and began to learn the cow business, is used by teamsters with a block and tackle attached for pulling wells."

Oil derricks came to dot the horizon, once vast stretches of prairie. The wealth that oil brought also brought business and commerce to the region and populated the area, which, in turn, took away land acreage for agriculture. Salt water that was extracted from the wells destroyed crops and tainted groundwater. Some welcomed what they saw as "progress." Others viewed oil as an end to a way of life.

Phillips Petroleum Co. Building, Bartlesville, Okla.

Frank and Lee Phillips, attracted by the oil boom, came to Oklahoma in 1904. They discovered oil north of Bartlesville and had 80 producing wells immediately thereafter. Phillips Petroleum Company was incorporated in Bartlesville in 1917. The company acquired a refinery in 1927, and in that same year, it opened its first gasoline station in Wichita, Kansas, and began selling the Phillips 66 brand. The company stayed in Bartlesville until it merged with another regional company, Conoco, which was headquartered in Ponca City for much of its early history. (Courtesy authors' collection.)

With the advent of refineries and automobiles, the oil industry soon moved into the gasoline-selling business. Many gas stations populated the countryside. The gas station pictured here was located in the town of Douglas, Oklahoma. With oil so plentiful in Oklahoma, small companies could compete with the larger corporations such as Standard, Getty, and Phillips. (Courtesy Phillip Moseley.)

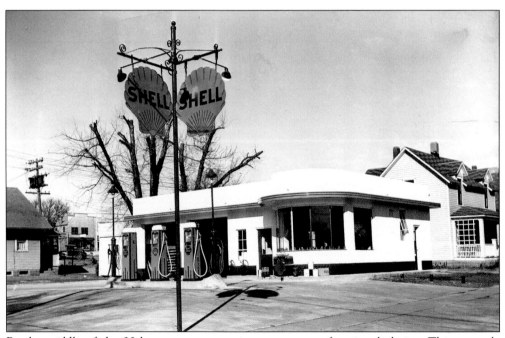

By the middle of the 20th century, gas stations were part of national chains. This example belonged to Shell. With its sleek art moderne lines, it was a far cry from the dust and tent cities newcomers to the outlet experienced just 50 years earlier.

By the early 1930s, drought and depression had settled on the central plains states, and futility hung in the air as thick as the dust in Oklahoma and Kansas. Huge black billowing clouds filled with dirt invaded the region with a vengeance. The dirt settled everywhere, causing a multitude of health problems, poverty, and despair. Many Oklahomans, dubbed "Okies," abandoned their farms and left the region, migrating to the western states in hopes of finding work. (Below, courtesy Wichita State University Libraries, Department of Special Collections.)

There were some Oklahomans who left during the drought and depression to return to their roots. Some such as John Robert Stoner (left) and Michael Wiley went to Winfield, Kansas, where Stoner found work as the Winfield marshal. (Courtesy Harley Anderson and Elma Stroad.)

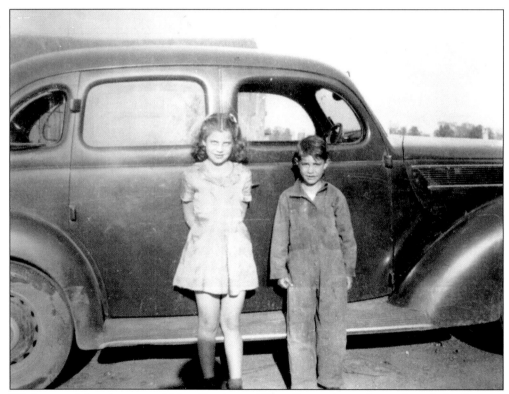

While many left, others stayed. Here Sondra and Doug Bruce, descendents of a rush family, pose at the side of a car in Deer Creek. (Courtesy Bret Carter.)

Having struck it rich in the oil fields of northern Oklahoma, oil baron E. W. Marland wanted to have a mansion on the prairie. This home had all of the latest and most modern technology of the day, including one of the first elevators in the state. His dream was not to last for long when he lost controlling authority over his own oil company and a series of personal setbacks tarnished his reputation. Later on, however, he returned to prominence when elected to the U.S. House of Representatives in 1932. In 1934, he became Oklahoma's governor and was known for his support of the New Deal. The company he founded lived on as the Continental Oil Company, or Conoco. (Courtesy Marland Mansion Museum.)

What was originally K County became, conveniently, Kay County. Its towns of Newkirk, Tonkawa, Ponca City, and Blackwell found themselves in competition in everything from railroad links to sports. With Newkirk the county seat, Ponca City the oil center, and Tonkawa the home of what became Northern Oklahoma College, Blackwell (above) hosted the county fair. In 1913, Blackwell commemorated the arrival of electricity to the area with this striking pavilion (below) patterned loosely after the Columbian Exposition buildings of Chicago. For years, it was an important, and at night well-lit, local institution. The pavilion is now home to the Top of Oklahoma Museum. (Courtesy authors' collection.)

Old Kaw City, founded in 1902 as a farming community on the fertile land of the oxbow bend of the Arkansas River, later became a booming town when oil was discovered nearby. Then a devastating flood in 1923 rocked the quiet little town, and effects of the Depression saw the city decline. Engineers began planning a way to deal with these issues and make Kaw City a better place to live. In the mid-1960s, the whole town began a relocation process as ground was broken by the Army Corps of Engineers to create a lake to handle the flooding problem and create an area of recreation. Old Kaw City now lies beneath the waters of Kaw Lake, as does the old settlement of Washunga. Now on the banks of Kaw Lake, the new Kaw City is a community of about 300 that enjoys panoramic lake views and easy access to Ponca City just 10 miles to the west. Kaw City is also the home to the Kaw Nation headquarters. (Below, courtesy Melissa Thompson.)

For a century, the Chilocco gateway welcomed Native Americans from the area into its halls. The school played an important role in their lives. The school opened in 1884, before the Cherokee Outlet rush, and operated long after the area was settled. Over time, schools such as Chilocco shifted from being tools for assimilation to institutions that taught the next generation of Native American leaders. (Courtesy Melissa Thompson.)

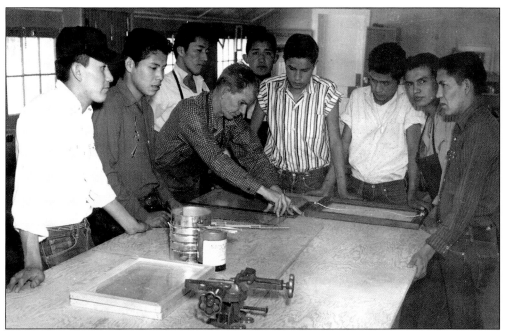

The Chilocco Indian School integrated academic learning with agricultural, life skills, and vocational training. Students spent their school day concentrating on each facet. Through this method of teaching, the school was able to provide food and clothing for students. Classes included homemaking, sewing, shop, farming, and other vocations. When it began, the school offered classes through the eighth grade. Later it offered education to students through the 10th grade. Elementary grades were eliminated in the late 1930s, and the school closed in 1980 although parents were opposed to its closure. To this day, the school has fostered relationships and created bonds among its Native American students.

The Miller brothers' 101 Ranch was known for its showmanship and became the set for several early Westerns. The 1912 picture above is a movie set on the ranch that may have possibly been used for their own production called *The Cherokee Strip*, which was released in January 1925. Hollywood has made many films about the land rush, including titles such as *The New Frontier*, *Ranger of the Cherokee Strip*, *The Topeka Terror*, both versions of, *Cimarron*, and, most recently, *Far and Away*.

Will Rogers was born in 1879 on a ranch in the Cherokee Nation. Oklahoma's favorite son, Rogers's lasso skills earned him many distinctions, including a listing in the *Guinness Book of World Records* for throwing and connecting three lassos at once. He also performed in a countless number of Wild West shows and vaudeville acts, where he honed his humor. He starred in more than 70 movies, was a popular broadcaster, wrote six books, and was syndicated in more than 4,000 newspapers. Although Rogers never finished high school, he was equally known for his "folksy" political and philosophical comments. On the right is a photograph of Rogers at 101 Ranch in Oklahoma Territory where he performed for the crowds that would gather to watch many famous people come through the showplace. Rogers was well known for many things, but his quotes keep being used to this day. One example of his political philosophies and humor is echoed in the following quote. "There's no trick to being a humorist when you have the whole government working for you." (Below, courtesy authors' collection.)

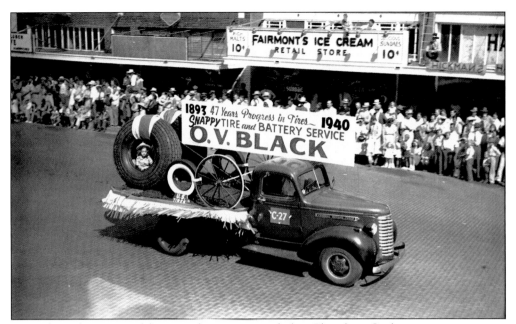

Festivals and events celebrating the opening of the Cherokee Outlet are important to remembering the legacy of the land. This float in the 1940 parade touts, "47 years progress," including paved streets, retail stores, improved modes of transportation, and hundreds of people eager to commemorate the land run. Events such as these are celebrated yearly in communities throughout the former outlet. (Courtesy Historic Images LLC—Falconer Collections.)

As the years passed, the region's memory of the 1893 rush shifted. Aging rushers wrote down stories and gave interviews that recounted the great hardships involved in making new lives in the outlet. Later generations, however, emphasized the romance, excitement, and nostalgia of the 1893 rush, overlooking the event's turbulent, violent, and uncomfortable aspects. Clothing and artifacts of daily life seemed to recall the "good old days" instead of the tensions and depression of the 1890s.

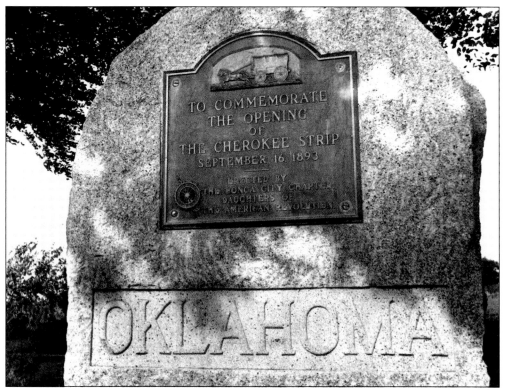

The region is dotted with historical markers that recall the days of 1893. Through these monuments, patriotic groups such as the Daughters of the American Revolution and communities such as Arkansas City celebrated the heroism and bravery of individuals who came to the 1893 run for a broad array of motives, from greed to adventure to desperation. (Courtesy James Coyne.)

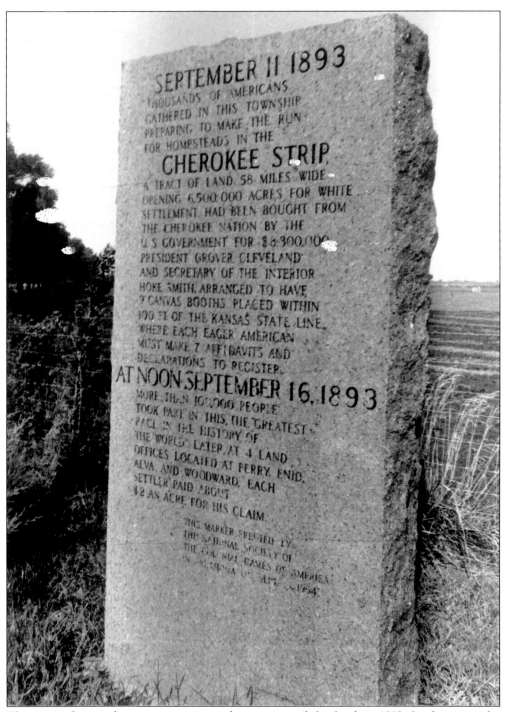

This is another marker commemorating the opening of the land in 1893. In this case, the National Society of Colonial Dames erected the monument. (Courtesy James Coyne.)

Initially a derisive term for someone who tried to stake a claim before lands officially opened up, the term "sooner" has undergone a transformation and is now a symbol for Oklahoma itself, particularly for fans of the University of Oklahoma. In the early 1900s, fans of the University of Oklahoma sports embraced sooner as a nickname. The school's fight song, "Boomer Sooner," connects that institution to the state's early history of the land rushes. The Sooner Schooner, seen above, emerged as an emblem of the institution in the 1960s and became the official image of University of Oklahoma athletics in 1980. (Courtesy the University of Oklahoma.)

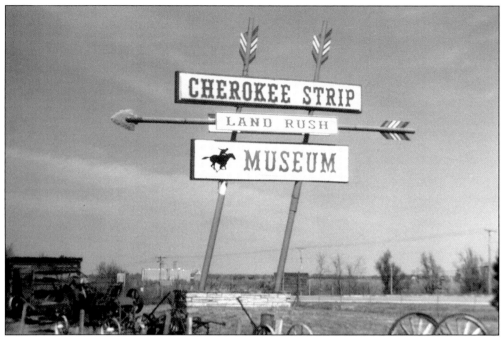

In 1966, the community of Arkansas City established the Cherokee Strip Land Rush Museum. Located in a building that once housed a bowling alley, the museum has grown to include exhibits on the rush, Arkansas City, and the region. The sign out front was copied from a motel sign in Blackwell. (Courtesy Jay M. Price.)

Once seen as obstacles to white progress, Native Americans are now considered embodiments of Oklahoma. Here a Pawnee delegation dances at the opening of the Cherokee Strip Land Rush Museum in Arkansas City.

Registration sites for the land rush were spaced along the Kansas and Oklahoma border and at sites settled by previous lotteries and runs in Oklahoma. Arkansas City, Kansas, was among those sites. The small Kansas town saw its population soar in the months and weeks prior to the land run. Some disappointed rushers even came back to settle in Arkansas City. Signs such as this remind visitors and locals alike that Arkansas City thought itself to be a "Gateway to the Cherokee Strip." (Courtesy Melissa Thompson.)

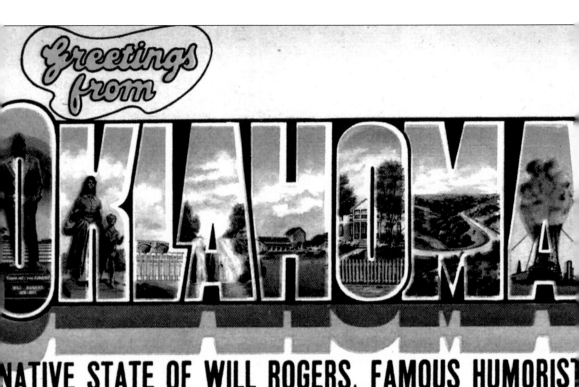

Postcards that celebrated state or local heritage were common in the mid-20th century. This one has several features that the artist considered embodiments of Oklahoma. Note how many of those features were connected in some way to the Cherokee Outlet. (Courtesy Curt Teich Postcard Archives, Lake County Discovery Museum.)

BIBLIOGRAPHY

Dale, Edward Everett, and Jesse Lee Rader. *Readings in Oklahoma History*. Evanston, IL: Row, Peterson and Company, 1930.

Daughters of the American Revolution, Ponca City Chapter. *The Last Run, Kay County, Oklahoma, 1893; Stories assembled by the Ponca City Chapter, Daughters of the American Revolution*. Ponca City, OK: The Courier Printing Company, 1939.

Draper, William R. *Exciting Adventures Along the Indian Frontier: A Reporter's Experiences in the Red Man's Territory and in the Old Cherokee Strip During the 90's*. Girard, KS: Haldeman-Julius Publications, 1946

Glasscock, Carl B. *Then Came Oil*. Indianapolis and New York: Bobbs-Merrill Company, 1938.

Hill, Luther. *A History of the State of Oklahoma*. Chicago and New York: The Lewis Publishing Company, 1909.

Hoig, Stan. *The Oklahoma Rush of 1889*. Oklahoma City, OK: Oklahoma Historical Society, 1984

Indian-Pioneer History Interviews. Oklahoma Historical Society, Oklahoma City.

Iorio, Sharon Hartin. *Faith's Harvest*. Norman: University of Oklahoma Press, 1999.

Kent, Ruth. *Oklahoma: A Guide to the Sooner State*. Norman: University of Oklahoma Press, 1957.

Lefebvre, Irene. *Cherokee Strip in Transition: a Documentary*. Enid, OK: Cherokee Strip Booster Club, 1992.

Milam, Joe. "The Opening of the Cherokee Outlet: The Run," *Chronicles of Oklahoma* 10 (March 1932): 115–137.

Morris, John Wesley, and Charles Goins. *Historical Atlas of Oklahoma*. Norman: University of Oklahoma Press, 1986.

Parker, Rev. J. H. "The Opening of the Cherokee Strip." *The Home Missionary* (January 1894): 449–453.

Pioneer Interviews. Oklahoma Historical Society, Oklahoma City.

Rainey, George. *The Cherokee Strip*. Guthrie, OK: Co-Operative Publishing Company, 1933.

Savage Jr., William W. *The Cherokee Strip Live Stock Association: Federal Regulation and the Cattleman's Last Frontier*. Columbia: University of Missouri Press, 1973

Unpublished collection of personal stories. Cherokee Strip Land Rush Museum, Arkansas City.

DISCOVER THOUSANDS OF LOCAL HISTORY BOOKS FEATURING MILLIONS OF VINTAGE IMAGES

Arcadia Publishing, the leading local history publisher in the United States, is committed to making history accessible and meaningful through publishing books that celebrate and preserve the heritage of America's people and places.

Find more books like this at
www.arcadiapublishing.com

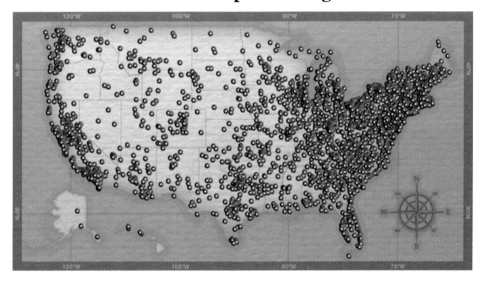

Search for your hometown history, your old stomping grounds, and even your favorite sports team.